A Unicorn Is Born

For my mother

A Unicorn Is Born

A TALE OF LOVE & MAGIC

BY TRINIE DALTON

ILLUSTRATIONS BY KATHRIN AYER

ABRAMS IMAGE

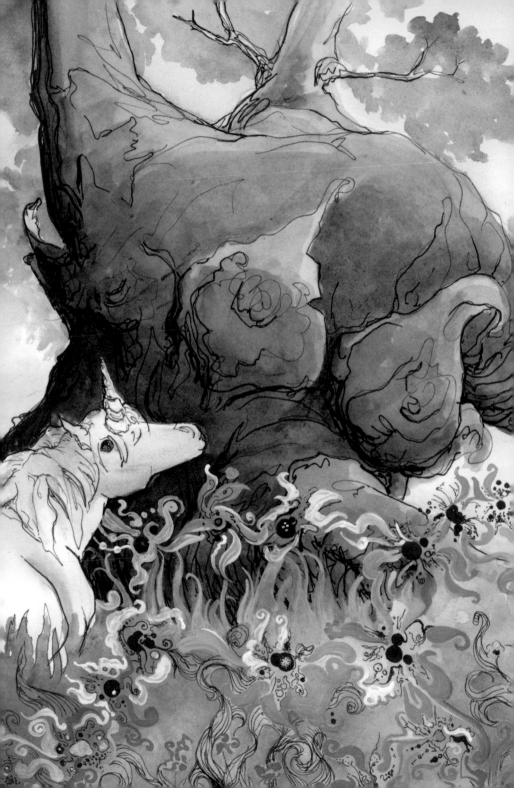

Part One

Part Two

Part One

Uma

My mother told me that to honor our species, firstborn unicorns should bear names that begin with the letter "U." It's exciting to imagine names for one's own baby! I find myself eavesdropping on the conversations of others, just listening for names. My name is Ursula. While I am a unicorn named after a bear—I am, indeed, strong and hairy like a bear—my mother named me astrologically, after the constellation: she saw *Ursula major* the night I was born, shimmering despite the full moon.

Quinn, my squirrel friend, is teaching me his method for brewing magical tea. I spent six dusks gathering herbs and roots. We've stashed pine needles, deerweed blossoms, blue-eyed grass bulbs, and white sage in the blackberry brambles where I like to sit out hot afternoons. I shoveled all of the forest's offerings into neat

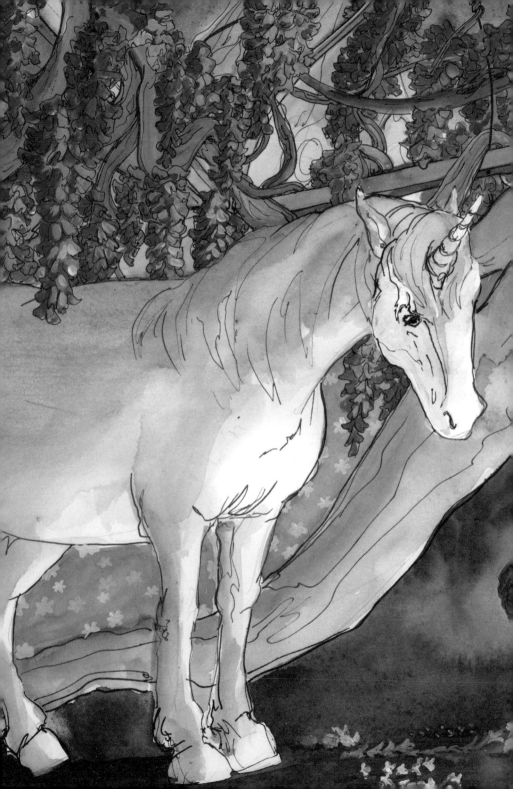

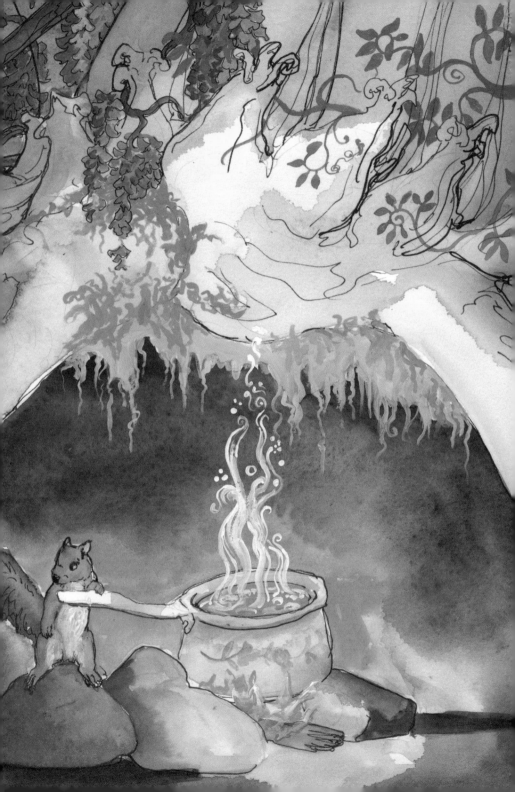

piles so that Quinn could choose what to infuse. I also gathered juniper berries, as I understand that they guard against theft, ghosts, and sickness, and keep snakes away. I always keep an abundance of them.

"*Juniperus communis* can be fatal to an unborn child," Quinn clicked angrily. He kicked the berries away, rejecting them from his recipe.

"But they smell so good. Besides," I reminded, "I can take the poison out."

Quinn lit up when he saw me piercing each juniper berry with my horn. Little golden sparks flew off the berries as if they were flint.

The story of my horn powers is long. Unicorns are famous for water-conning, and we're commonly spotted with our heads tilted down, horn to water, purifying streams. I refuse to sip any liquid unless my horn has touched it. Purification is a skill that has taken hundreds of years to perfect. Overdoing it can distill the goodness out of something: I could leach out nutritious minerals or deplete the oxygen supply on which fish depend if I were to keep my horn in the stream for too long. Unicorns can cleanse anything with their horns. This purification process is homeopathic—my horn contains a protein that, when combined with poisons, neutralizes them on

the spot. The juniper berries are drained of tannins that are too acidic for pregnant unicorns. Quinn understood because he extracts a similar tannin from his acorns. Quinn gathered my cured berries, and felt a little embarrassed that he'd forgotten I could put anything I desired into our tea.

Standing back from Quinn's medicinal blend, now in a tidy pile ready to scoop into the pot, I relaxed my neck by leaning my head against the wall of our giant bramble den. I ruminated on "U" names. I thought of elders I knew as a child: Ula (or Sea Jewel); Una (All One); Uberto (Bright Heart); Utina (Country Woman); and Uther (Dragonmaster). Then, I started mentally compiling a list to choose from: Unica, Ulysses, Ulivia...

As night fell, Quinn built a little campfire and boiled water over it in a cauldron. He tossed the tea mix in, I gave the water a quick stir with my horn, and we watched it simmer. The tea bubbled, and steam wafted up into my nostrils. The pine-juniper-sage tea had powerful nutty, sugary, and bitter flavors. When the coals had burned down into crackling orange embers, we poised our faces over the pot and lapped up the luxurious drink. Immediately, I felt my coat thicken and grow,

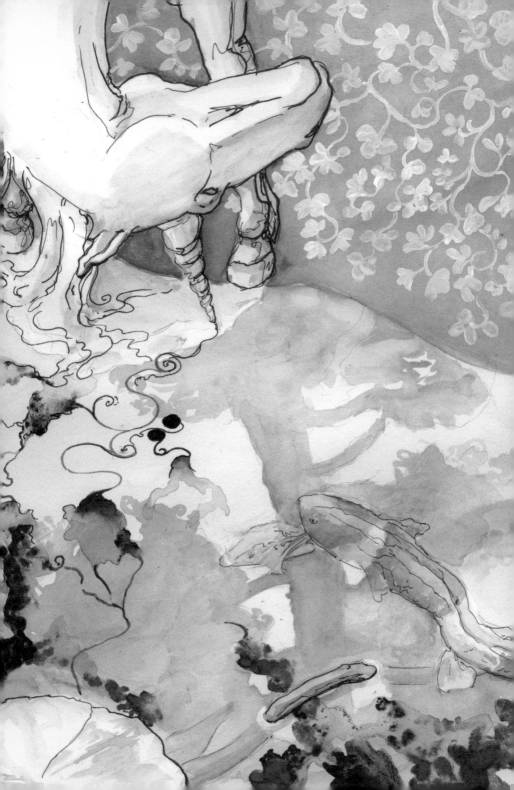

just as Quinn had predicted. My coat, mane, forelock, and tail suddenly felt luminous and delicate after the drink. Quinn's sorcery always works.

"Celestial!" I praised Quinn and scratched my hoof on the dirt in applause.

"So it is. The blend's called 'Unusually Musical.' It encourages poetic language. What, then, will you name the baby?" Quinn chirped, reminding me of our goal this evening. He leaned against the rounded wall opposite me, and tapped his paws on the dandelion flower–covered floor.

"Don't worry, Ursula. It will come to you…" Quinn looked deep into my eyes.

At that very moment, I yelped, "Uma."

Quinn smiled. "It's a girl!"

Honey Horn

Before I conceived Uma, I was six hundred years old, almost halfway through my life, and wondered whether or not I was too old to become a mother. If I were lucky enough to live to the old age of 1,500, I would see my future child go from being a lively mare, to mother of her own unicorn, to queen of everything. Stags only mate every fifty years, so the unicorn life cycle unfolds gradually. It was depressing to consider how many more full moons I'd watch, waiting to bear a child.

We are solitary roamers, and during lonely spells I felt an urge for some familial company. Filled with joy at the thought of having a child, unlike any other I'd ever imagined, I played in the forest alone. I gathered piles of leaves and pranced and hopped around them. I coveted other animals' children, and I probably would have adopted a young skunk or rabbit if the opportunity arose.

I was ready for this new life phase, and was confident I could pass my unicorn secrets on to my child with some authority. I didn't have female clan members with whom I could discuss childbearing, so I couldn't gauge where this baby craving first came from. Was I feeling isolated, or did this simply mean that my equine biological clock was ticking? Only occasionally did I encounter other unicorns in the forest, and this was usually during mane decorating fairs. The last year I participated in one was the year I got pregnant with Uma.

It was the Year of the Amethyst according to the Mystical Forest Calendar. Purple quartz is rare in the Elfin Forest, where the fair was elected to take place. The forest's earth consists of speckled salt-and-pepper granite out-croppings, mica, and sandstone. Sometimes orange jade or pink copper may be found in riverbeds, but it's not a region known for gemstones or precious metals. But I knew all the secret caverns with amethyst crystals, so I planned on bejeweling my mane with crystal tips from geodes.

Every fifty years in spring, the Honey Horn Mane Decorating Fair occurs in a forest chosen by the elders. A designated site is cleared, then deer and raccoons con-struct a stone and log ring where the unicorns play. It's

always in the oldest and most secluded area of the forest. Participant numbers vary. This particular year, there were seven of us. It's an honor to attend, and all unicorns who participate receive colorful ribbons.

A female unicorn in estrus has what's called a honey horn. The mane-decorating festivities are really a chance for unicorns to gather, share the secrets of the universe, and lick each other's horns. (This is where the word "horny" originates.) A sweet, sticky substance leaks out of the pores in our foreheads and covers our horns to attract mates. Some have compared the scent of unicorn honey to cotton candy or cake frosting.

For the Honey Horn Mane Decorating Fair, I had to round up a decorating crew to gather flowers and gems, and to apply them to my mane and horn. Over the course of three days, I enlisted two mourning doves, four black phoebes, and a scrub jay to weave the decorations in and out of my hair. Amethysts were braided into my mane and forelock so that the crystals would reflect lavender rays off of my honey horn.

I, Ursula, am a *Unicornuus memorensis*, a Forest Unicorn, and Forest Unicorns are known for their wit, integrity, and ancient forest knowledge. Flower Meadow

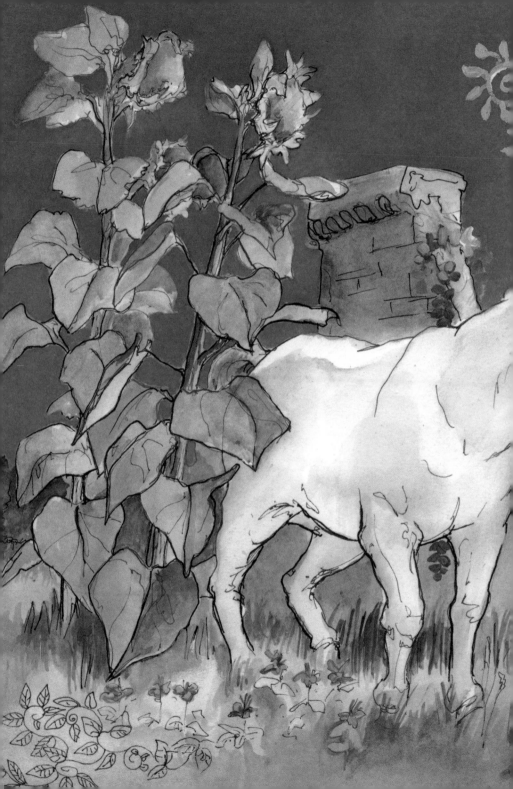

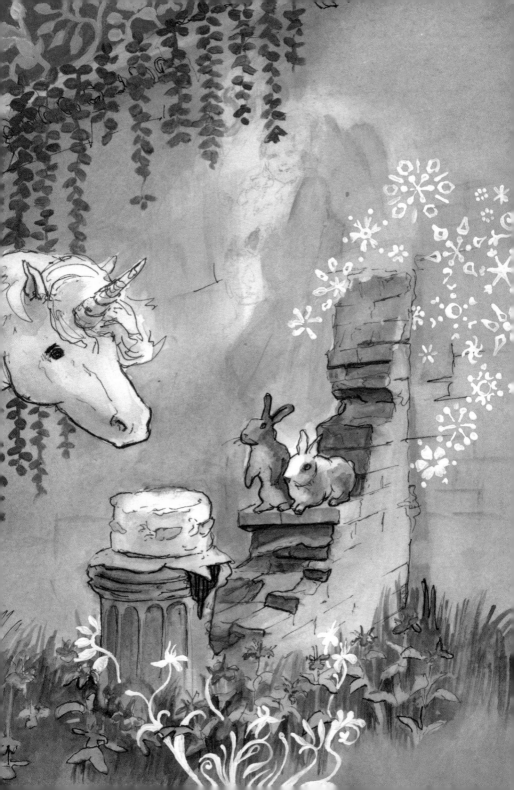

Unicorns, *Unicornuus floreus*, on the other hand, always
do the best mane decorating, because they live in color-
ful meadows year-round and are more advanced color
theorists and floral designers. Amethysts were my unique
decorative feature that year, and the flowers I chose
represented the other colors in the spectrum: peonies
(red), orange Indian paintbrushes (orange), wallflowers
(yellow), fairy lanterns (green), and wooly blue curls
(blue). The Flower Unicorns loved my combination, and
I loved theirs. One resourceful Snow Unicorn had traded
with a Jungle Unicorn some alpine heather for giant
gardenias, plumeria, and tuberose, and had laced her
snowy mane with the fragrant, tropical blooms. Unicorns
cherish these festivals for visiting and loving each other,
and especially for sharing our knowledge of sustaining
our magical forests for all of eternity. Unicorns are allied
by our respect for nature. The alchemy of idealism, the
separation it contains, and what must propagate and
be realized. With or without flowers, we all win in the
Honey Horn Mane Decorating Fair, as we understand the
importance of beauty to each other.

As I said, the fair is primarily an invitation for honey-
hunting stags who are ready to mate. Fresh blueberries,
gathered in a land far north, were the prize. We ate them
out of miniature cornucopia-shaped baskets woven by

wood rats. The festival ended late in the night, with pairs of unicorns trotting off into the shrubbery, or leaving to take strolls along the Romantic Honey Trails that had been cleared expressly for this occasion.

As I wandered home, a stag approached me. I noticed that he had an odd tuft of tan beard hairs, which made him look especially handsome. Unicorn colts have baby beards that fall off on their first birthdays, at the same time that their eyes turn from blue to black. This beard signaled to me that this stag had exceptional wizardry skills. Maybe he had the power to change color. I'd never seen tan hairs on a unicorn. He reminded me of a bear, my namesake animal. He was exquisite.

Uma was conceived on the eighth day that the tan-bearded stag and I spent together on the Elfin Forest's Romantic Honey Trails. Since no human has ever witnessed mating unicorns, I must save the details of our love-making. For now, guess what Uma's birthstone will be, since she came to us in the Year of the Amethyst?

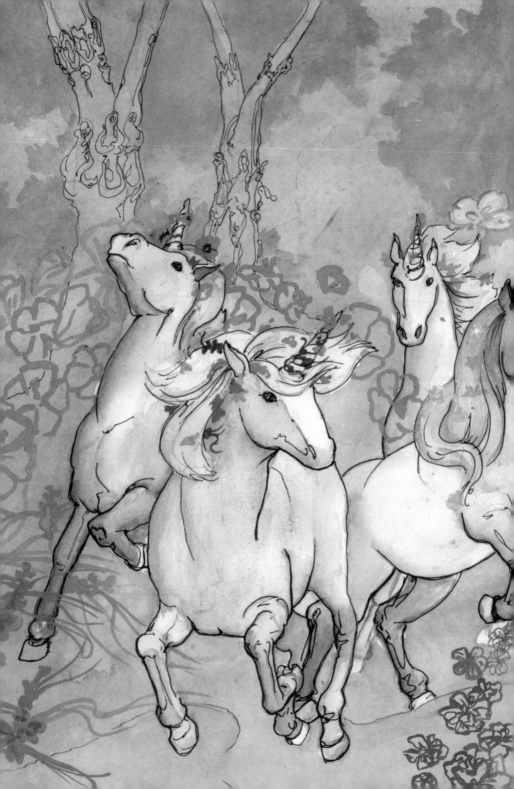

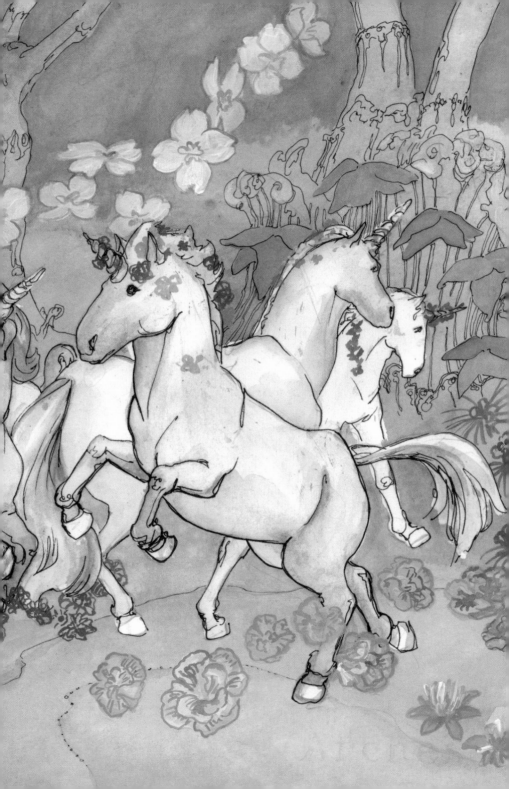

Rainbow Cravings

A few months before Uma was born, I developed an obsession for rainbows. My mind told me to walk all day, every day, in search of the biggest, fullest arcs, but my body told me to lie still and rest so Uma could grow into a healthy colt. But I was too excited and felt antsy for visuals, as if Uma wanted to witness everything before her eyes even opened. We both wanted to examine the world, Uma for the first time, and I, as the watchful parent on lookout, editing Uma's view. Rainbows are great in every life stage. That's why I had the urge to appreciate them immediately.

Because of the pregnancy, I slept more than usual, up to eleven hours a day. It was early summer, and the days were getting brighter, longer, and hotter. Being fair, I sunburn easily, so I burrowed into shady glades or bushes for the greater part of each afternoon. Excessive

daytime slumbering boosted my energy, and I assumed rainbow viewing would only increase my maternal potential. Obsessions that sprout from a physical need to calm one's nerves, I've found, tend to result in mental relaxation even if the exercise is exhausting. So I walked at night, anticipating rainbows each sunrise.

This particular summer, the thunderstorms generated marvelous rainbows, and I considered it doubly lucky that lightning finales topped off the sky's rainbow shows. For some reason, the lightning stayed a safe distance above, never threatening to connect with the land. I formed multiple theories about this: maybe the rain and mud had encouraged rotten trees to collapse under their own weight, so that there were fewer tall conductors for lightning to find; or maybe there were fewer mead- ows for lightning to strike, since eutrophication had set in—many of them had significant oak tree forests bud- ding where algae and bog plants, such as arrowheads, had once resided. Perhaps the thunderstorms were spectacular because it was the Year of the Fire Opal, our most colorful calendar year. Fast-moving thunderstorms, with their rain-sun-cloud-rain-sun sequences, produce righteous rainbows. In any case, it was safe enough to stand out in the rain right under the action, where I had the most astounding views.

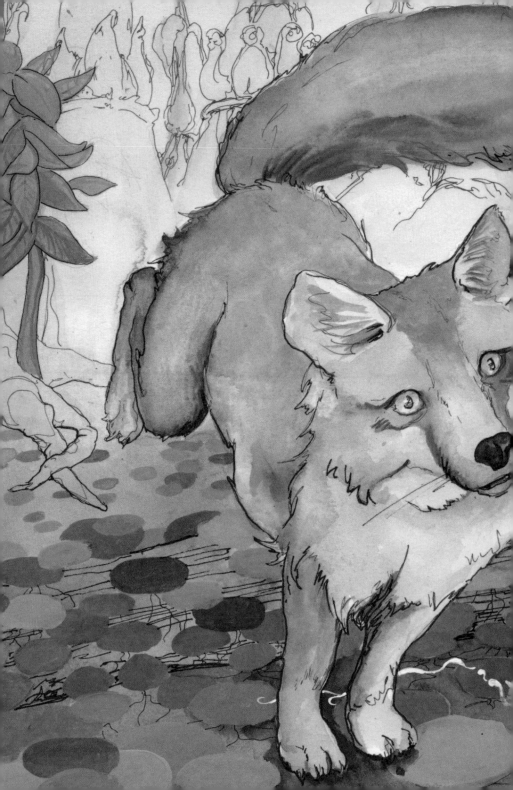

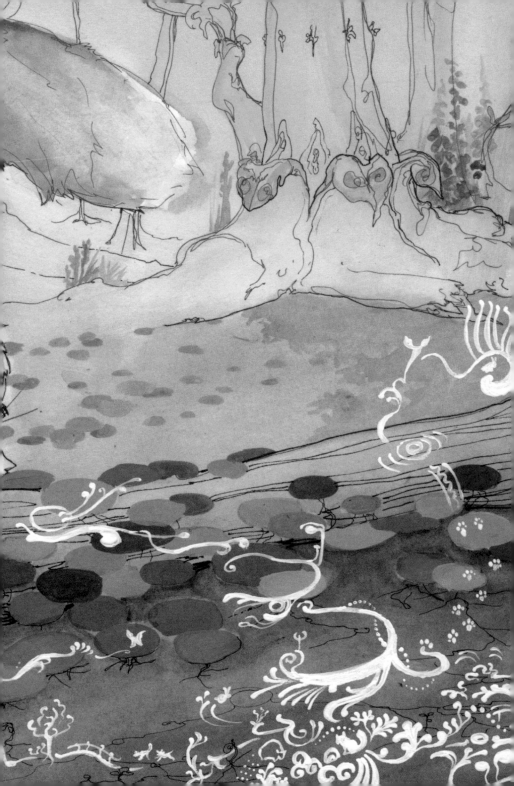

Despite skeptics like Arf, the gray fox who kindly escorted me on rainbow excursions to make sure I didn't sprain an ankle or slip and fall on my bulging, fragile belly, I still maintain that standing beneath as many rainbows as possible during pregnancy is not only a charming way to cheer the mother anticipating her painful event, but it also aligns the baby inside the body for smoother delivery. Air is magnetized beneath a rainbow, which is why the colors clarify, and I believe whichever direction the rainbow is facing while a unicorn admires it is the way her baby will be born. I invented this legend one night while Arf and I were traveling across a chaparral plateau. Arf didn't believe in the influence of rainbows.

"Of course you can choose which direction your baby will be born," Arf said. "You can face your body any way you want. It's not magic. My first baby was born upside down." Arf had a lustrous, dense gray coat, and it was hard to imagine any newborn pup finding its way out of that fur, much less upside down.

"Upside down?" I asked. "I'm so sorry..."

"It wasn't that bad," Arf explained. "I was rooting around, face-down in a rabbit den. My pup popped right out and started barking. A pack mate, who saw the whole thing happen, said that my Arfling looked like a gopher coming out of its hole."

Arf stopped to sniff a puddle. I loved watching her nose twitch while she caught scents. It made her whiskers seem alive, like a hundred mini-Arfs were populating her face. She inhaled the water's aroma as if it were her dream meal. I asked her what foxes like to eat.

"We like meat," Arf said. "Mammal, fish, fowl, insect. And I personally love fern brackens."

"I love fern brackens, too," I replied, feeling relieved that we had something in common. "Arf, do you think the reason I'm a vegetarian is because I've seen too much beauty?" I added.

Arf asked me to elaborate.

"Perhaps if you see too many nice things in the world, it cancels out a will to kill," I said.

Arf laughed. "Nothing keeps me from hunting. Catching prey is my favorite thing to do."

I wondered if our brains were so different, or if we had simply learned to eat the opposite things so that there'd be nourishment for every animal we shared the forest with.

Arf was a good fox to walk with. She told me stories (for example the baby born upside down tale) to take my mind off of how heavy my body was getting. I looked like a farm cow, my sides pressing out elliptically, nearly tripling my size. On trail sections that required my

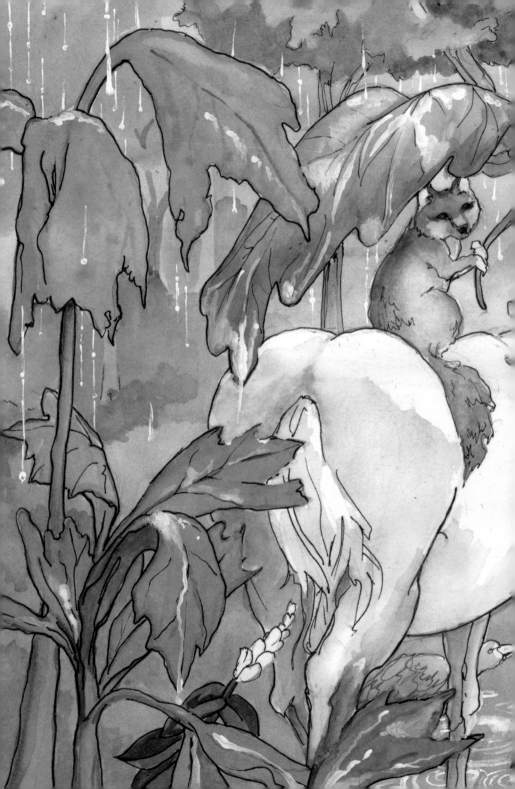

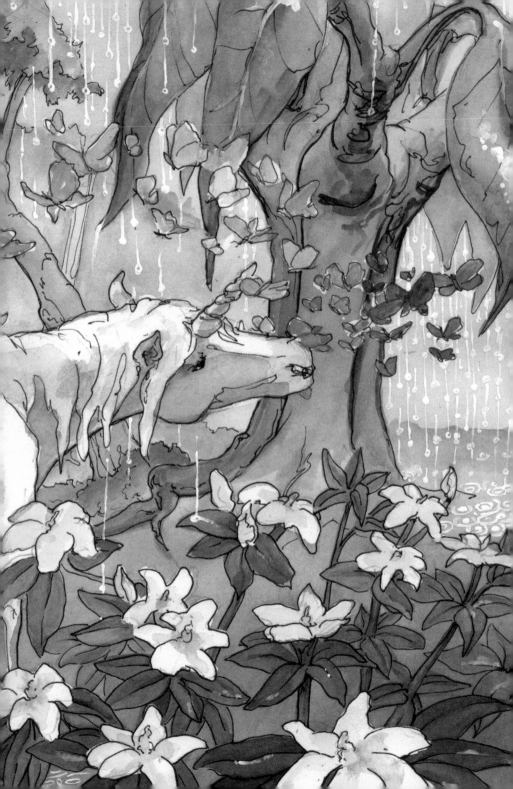

squeezing between two trees, I'd sometimes get wedged between them. I had to sleep standing up, which made my hooves ache. My back constantly hurt, so Arf would climb up and massage it with her paws.

For the rainbow shows, Arf was my best friend. I got smarter considering her ideas, most of which were things unicorns avoid thinking about—such as, why we have an aversion to killing. I kept wondering why those at the top of the food chain are carnivorous. I'd always figured unicorns were at the top because of our magical intelligence, but maybe I was wrong. Perhaps it was wrong that the animal kingdom allowed killers to be dominant. Or maybe all beasts were equal, each having their own good qualities. Arf taught me that I hunt, too, but for other things, not live creatures.

Most unicorns won't even utter the word "kill," because our sentences are spells. If we want something to happen, we say it aloud. Words are constructed of phonetically sophisticated consonant and vowel sounds, and they vibrate through our bodies and tune us in to our true desires.

Rainbows, on the other hand, vibrate with light. Light that has passed through raindrops breaks down into

various colors. Each color has its own wavelength, so
the light divides into bands. Red waves are the longest,
orange are second longest, and so on, which explains
why a rainbow's colors seem to bow into an arc. Now
I fully understood the unicorn's deep connection to
rainbows. Each unicorn in her expectant stage bonds to
a certain rainbow style, which forecasts the mother-child
relationship. If she is drawn to delicate, pastel, pencil-thin
rainbows, dealings with her child will be mellow. If she
likes dark evening rainbows surrounded by charcoal-gray
storm clouds, her parental experience may be tumultuous.
I was attracted to marbled rainbows because I wanted
my time with Uma to be prismatic, dynamic, and exciting.
I hoped she would be flexible, like the colors in a rain-
bow's evaporation, twisting and blurring into the wind.

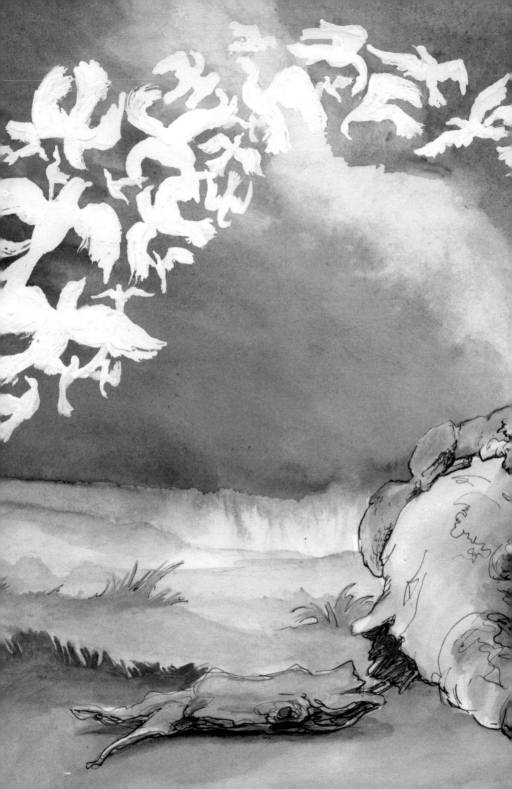

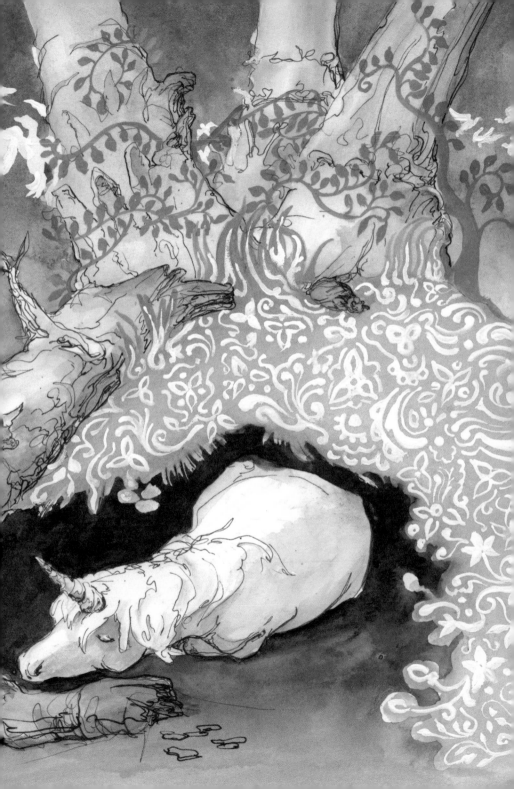

The Ecstatic Mosaics

Infinite, amazing realizations came to me on the days leading up to Uma's birth. After having aligned her on my auspicious rainbow journeys, I felt ready to receive all motherly information as if it were radio waves floating by and I merely had to put up my antenna. My three-year pregnancy was nearing its end. As late summer became fall, Arf and I returned from our traverse across the Elfin Forest, having viewed every rainbow we could. Arf went east to meet her red cousins, the kit foxes. I stayed in the Elfin Forest, searching for a place to have my daughter. I rummaged through every shrub, hole, and cave, using my nose and my horn's vibrational force—it's like dowsing, only I can sense more than water. My main criteria for a place to deliver were based on comfort: was it warm, could it be lined with soft padding, was it safely enclosed, and was it dark? I liked the cave idea, since stalactites make horned

animals feel right at home, but it's chilly underground, and I needed light.

My subterranean research turned terrestrial. Never before had I so carefully inspected every inch of dirt, every twig, every pebble, to assess the nutritional value and mineral content of the exact place Uma would first touch earth. I wanted her birthplace to enrich her world-view. I wanted it to be a place I could return to with her, a place she would revere.

The word "nutrition" buzzed in my head. Sometimes its three-syllable rhythm kept me company like a song as I repeated it on walks or while chewing my meals. I became increasingly conscious of what my body was tell-ing me to ingest, and it was clear that Uma had her own tastes and appetites. Since I was close to giving birth, my teats were drooping with unicorn milk, and I imag-ined the foods I ate would flavor it. Based on the foods I craved—rosemary and sumac—Uma already had a taste for the savory.

Given my dietary independence, I tend toward grasses, especially wild oats. I also relish rosehips, oak bark, bay laurel berries, mahogany leaves, pussy willow buds, lem-onade berries, miner's lettuce, horehound, chia, lamb's

quarters, dandelion, purslane, amaranth, and manzanita. Most of my protein comes from soil, but if I am weak or dizzy, I'll choke down snails and worms. Unicorns do not normally eat mushrooms, but these past days I felt an instinctual urge for fungi. This was tricky to satisfy during the dry season. I altered the nutrition chant to "nutritious mushroom" to discover location clues.

Nevertheless, for two days no mushrooms were to be found. A red-winged blackbird claimed he had seen some wood blewits months ago, but didn't recall where. A mole had stashed an agaricus in her nest, but she'd eaten it. Finally, a brown mouse gave me some solid advice and told me to look where it was wet, pointing out ravines where cottonwood and alder groves retained some moisture. I wandered a switchback trail down a steep incline into the lowest part of the Elfin Forest, desperate for what fellow animals described as the buttery flavor of waterlogged oyster mushrooms.

I dug through leaf litter and rooted around tree trunks until my horn was filthy and my neck was sore from hunching over. My tail stayed busy flicking mosquitoes away. Pausing to rest, I folded my legs beneath me to sit in a spot where the tree canopy was interrupted by

rays of late afternoon sun. Pools of water, remnants of a seasonal stream, contained salamanders that squirmed through soggy twig piles. Discouraged, I kicked some rocks, clearing a place to draw stars in the sand. This would clean my horn tip, thus strengthening my vibrational force—plus doodling often gives me inspiration.

I drew one star, and then another. I etched a circle around the stars, then added more stars and circles, with squares to fill in the blanks, until I had a mosaic of the universal promontory, maplike in its angular detail. I cleared more rocks away, and drew more mosaics, tiling the ground with geometric shapes. Since most minerals crystallize into one of seven basic crystal formations— cubic, hexagonal, tetragonal, orthorhombic, monoclinic, triclinic, or trigonal—I employed those shapes in my patterns to impose order upon my chaotic, random search for an elusive food.

Sitting on the ground, I had a bird's-eye view of the fallen leaves. Between them were many mushrooms that from above were nearly hidden by their color and texture. I hadn't noticed them before, although they'd been all around me. I whinnied with delight several times while standing up to investigate.

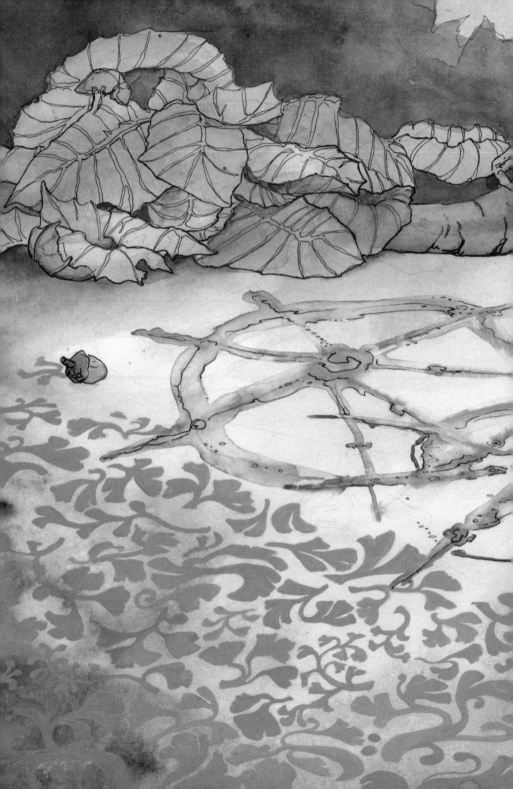

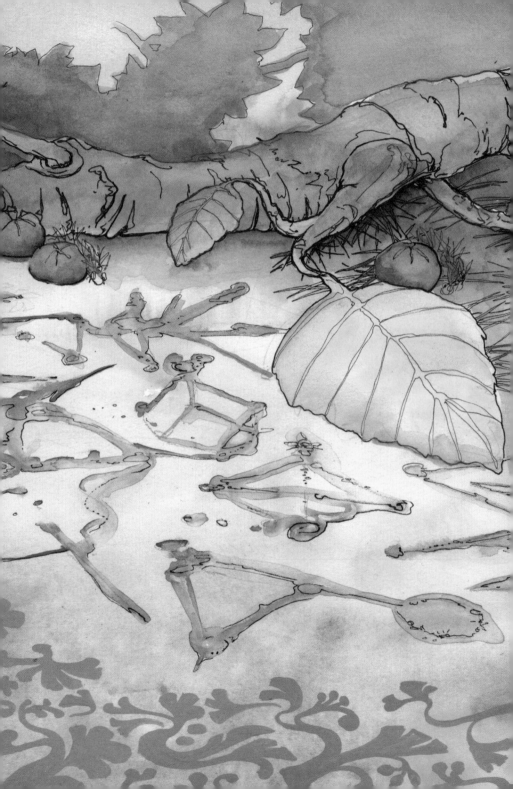

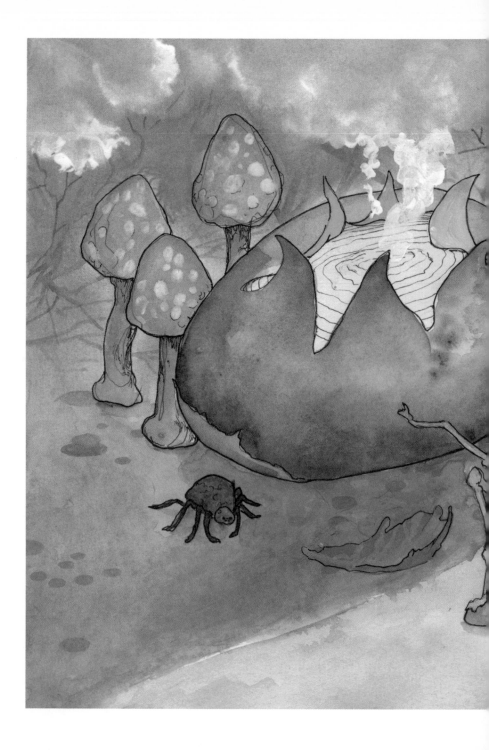

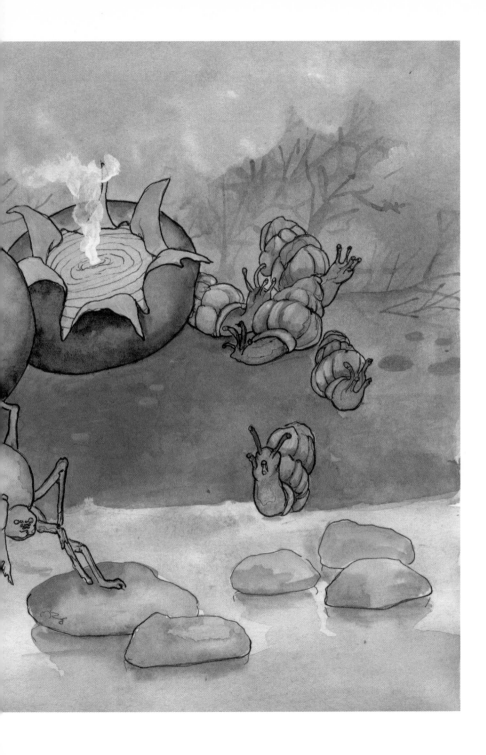

This fungus was scrumptious. Each bite had a puffy, spongy texture once the leathery outside casing was peeled back, for which I used my front incisors. The mushrooms were stemless, round, dark brown, and the tops opened up into six-pointed stars where spore dust floated out, which made me sneeze. The mouse had mentioned that I might find earthstars!

I devoured them all, visually breaking their shapes down into the basic forms I'd made with the mosaics. After all, these fundamental shapes—triangles, tetrahedrons, spheres, squares, and cubes—are the outcome of the same natural laws that define the growth of people, plants, and crystals. This is how the animal, plant, and mineral kingdoms relate.

It was getting dark. Shadows warped the round river stones and trees became blue-black silhouettes against the sky. My white coat looked gray during this time of day, which made me feel old. Was I really capable of being a good mother?

I looked up at the two main mountains that formed this canyon's walls, and noticed their uncanny symmetry. Tracing their slopes downward, each started with a jagged peak, followed by a slow curve, then a sheer cliff,

then a mild final hill before hitting the bottom of the valley. They could almost have been the same mountain, minus the way light hit them differently on account of their placement geographically.

I'd been to a lake once that reflected the mountains with a mirrorlike effect, but I'd never seen mountains that seemed to mirror each other. Since Uma would surely want mushroom-flavored milk, and I was only a day or two away from delivering her, I decided that Perfectly Symmetrical Canyon would be the ideal nursery.

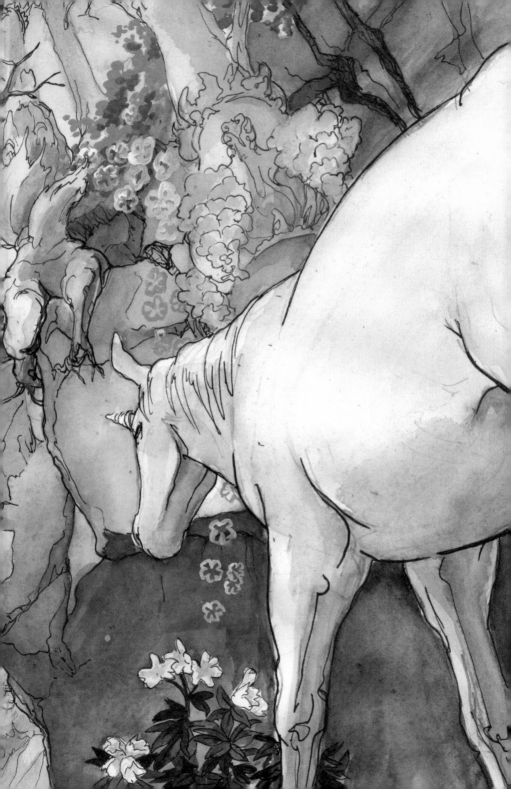

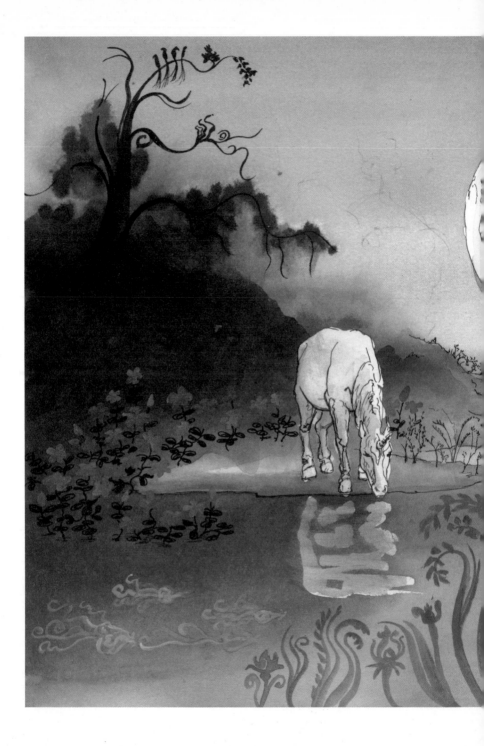

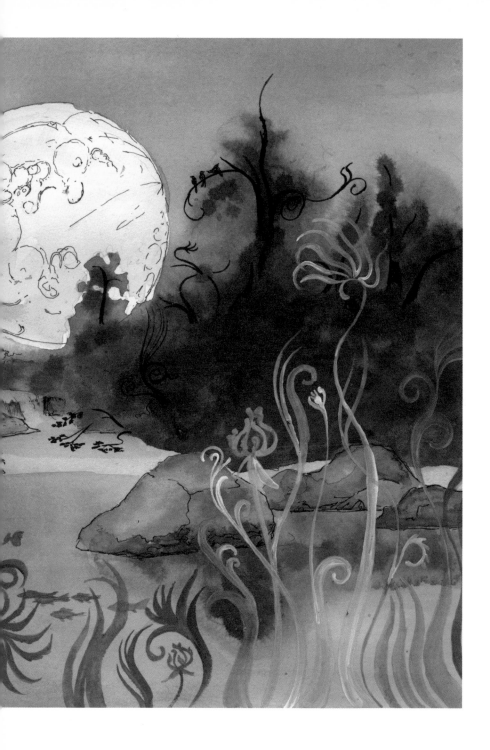

Physical, Mystical, and Universal Birth

Warning: observing a unicorn birth may drive you insane with happiness! Never before has a human seen a unicorn being born, because it happens outside time, in an alternate dimension called Original Destiny. A unicorn must find the correct vortex to access Original Destiny; if the destination is erroneously chosen, her unicorn colt will disintegrate into a fine dust that blows away after the mother is done giving birth.

I, Ursula, predicted that the earthstar patch in Perfectly Symmetrical Canyon was a portal to Original Destiny, because the moon rose exactly between the two mountains as if they were pyramids designed to accent it. The

canyon's geology was proof that unicorn evolution could succeed there in sympathy with our ancestors.

At twilight on day thirteen, month eight, Year of the Fire Opal, I had occult premonitions that Uma would be born before dawn. First, owl hoots occurred in patterns of three and five—whoo-whoo-whoo, and whoo-whoo-whoo-whoo-whoo—the same rhythm in which I'd conjured "nu-tri-tious mush-rooms." Also that day, intense cramping made me pass out, and while unconscious, I envisioned making eye contact with Uma for the first time.

I finished readying my nest, lining it with velvety syca-more leaves and crumpled pine needles for cushioning. While arranging the leaves, Quinn dropped in and delivered a sweet bouquet of mistletoe and mimulus, also known as monkey flowers. He said he'd be lodging a few trees away in case I needed help during the night.

The moon rose, and the owl who had heralded the event perched on a branch above me to guard my secret nocturnal delivery. Unicorns never give birth in daylight—there is too much opportunity for others to discover the most sacred occurrence of our species. It is so rare that unicorns give birth, and so many hunters are anxious to capture a baby unicorn, that even our friends,

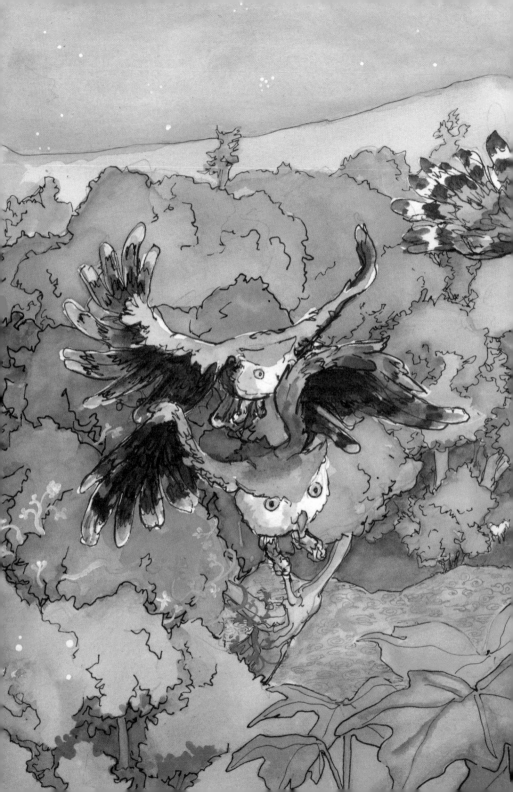

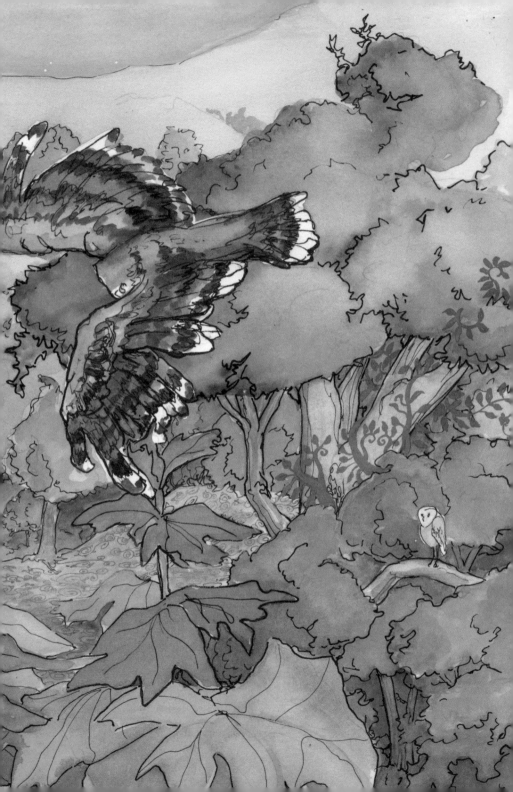

while present, are not permitted to actually watch. This was the most clandestine event of my life.

Unicorns have most infamously been coveted for their horns, as virgin-capture legends have told. Our alicorns, also called true unicorn horns or *verum cornu monocerotis*, are powerful medicinal talismans, but most people don't know that their strength diminishes the instant they are cut from the unicorn's head. The horn's curative ability depends upon a glandular substance that is manufactured in the muscles in our heads surrounding it. Still, humans also believe that other unicorn parts are valuable. Our livers, boiled into a salve, are said to repel leprosy. Shoes made of unicorn leather have allegedly helped soothe sore feet.

However the legend that most endangers Uma's life claims that wearing a unicorn pelt provides one with the ability to shapeshift and become invisible. I do have nerve-triggering vibrational force in my horn that enables me to vanish, but wearing my pelt certainly wouldn't work for this. Poachers have sought baby unicorn pelts for centuries, and fortunately we've always managed to foil them. On this occasion, my friend the owl stood by to help or to warn me if someone or something was approaching.

It was nearly midnight when my contractions increased to every ten minutes. I'd been standing in the nest, but my legs were so weak during the muscle spasms that I was forced to lie down until I felt my first urge to push. I instantly stood up and craned my neck back to see if Uma's head had begun to emerge. It hadn't. I pushed five more times, each with a few minutes between to catch my breath, before the baby began to show. The entire process took several hours. The whole time, I inhaled eucalyptus incense smoke, which reminded me to breathe deeply. Also, I faced straight ahead to keep my body stretched. Finally, Uma was born! She was drenched, but breathing and blinking her eyes. It took fifteen minutes of my licking her to realize that there was something magical about my baby already—her hair was dark brown!

I thought that Uma was the most beautiful unicorn ever born. I could tell immediately that she was going to be genuine, sincere, admirable, appreciative, respectful, affectionate, humble, unselfish, and sympathetic, on top of being lovely. I felt that every creature who laid eyes upon Uma would love her. My enthusiasm and pride were a hundred times stronger that I'd expected. Uma was just born, and I already loved her more than anything else in the world. Her brown coat didn't surprise

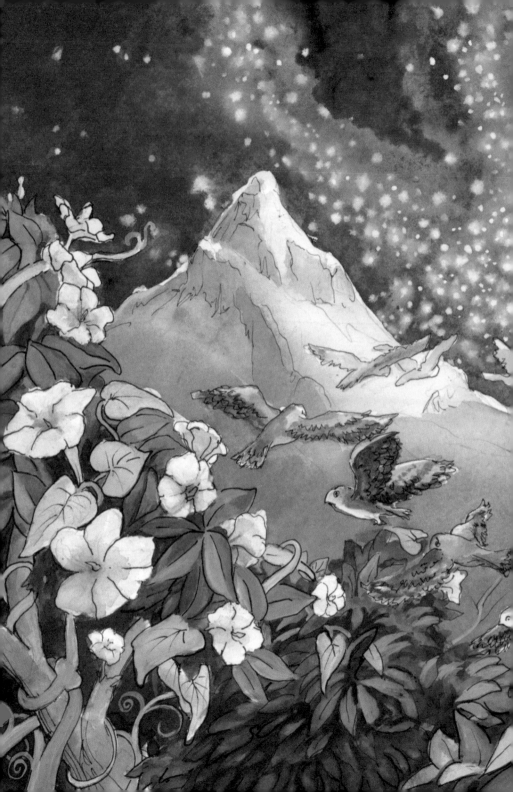

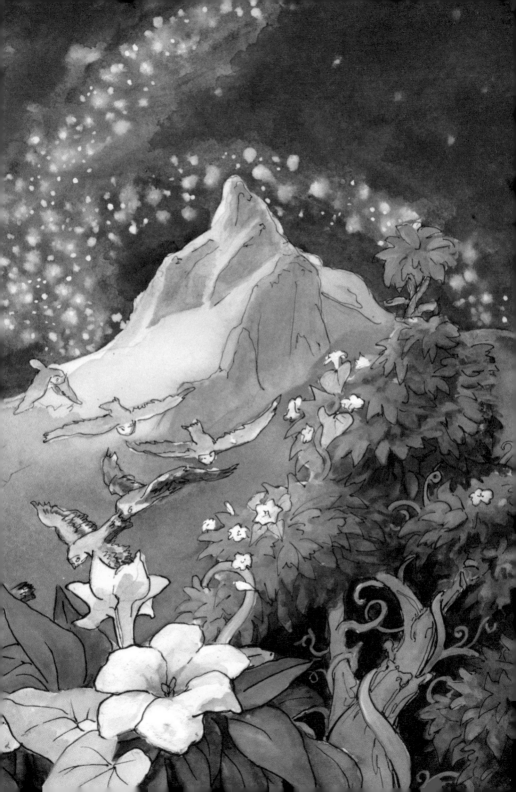

me, on second thought, because she was an intelligent expression of life, a creature representing every aspect of total awesomeness. She was going to be an important part of making the next few centuries worth living.

Uma's whinny was high-pitched and endearing. After her first cry, I offered her some milk and she smiled while she suckled. She drank for six hours, and then fell asleep nudging me with her leathery black nose. I was sweaty and barely able to stay awake myself, so I called up to the owl for him to keep watch while I slept.

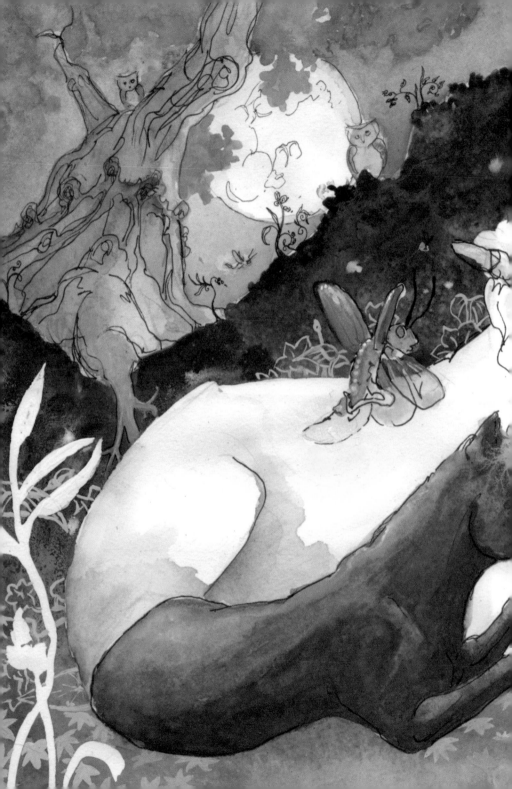

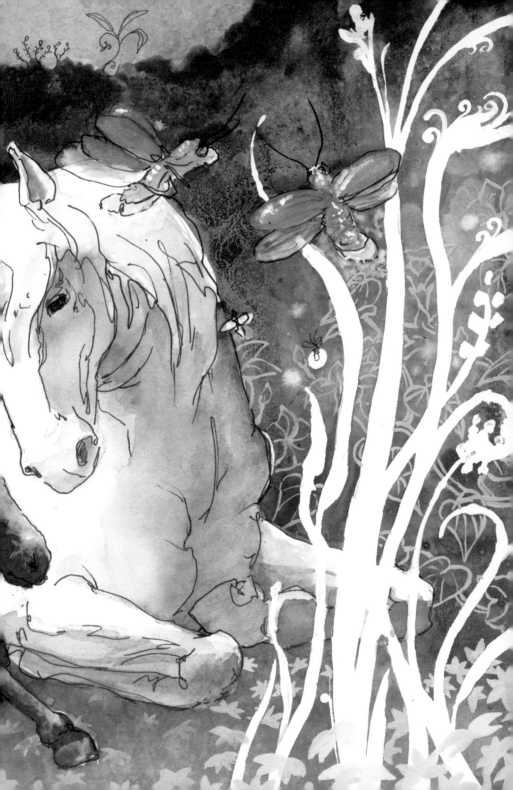

Part Two

Harmony in Perfectly Symmetrical Canyon

If one said that I'd had Uma in a canyon, under a full moon, they would have been correct. But it would be more correct to say that Original Destiny had unfolded and Uma and I, mother Ursula, had stepped up to take part in it. I knew the birth had been cosmically empowered because when my daughter awoke from her first night of sleep, she found a wreath on her head, full of herbs and flowers that were not from the Elfin Forest but from various jungles and woodlands beyond: calla lilies for everlasting beauty, magnolias for the love of nature, myrtle for fertility, and yellow jasmine for grace. It was a Welcome Unicorn Wreath, and each of us gets only one per lifetime.

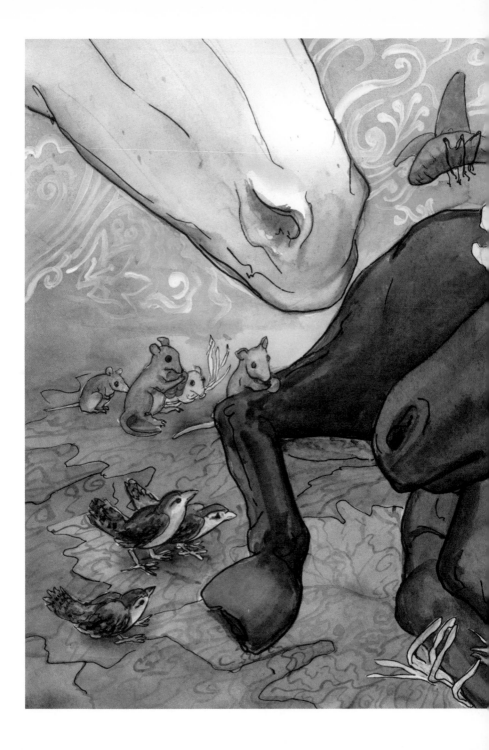

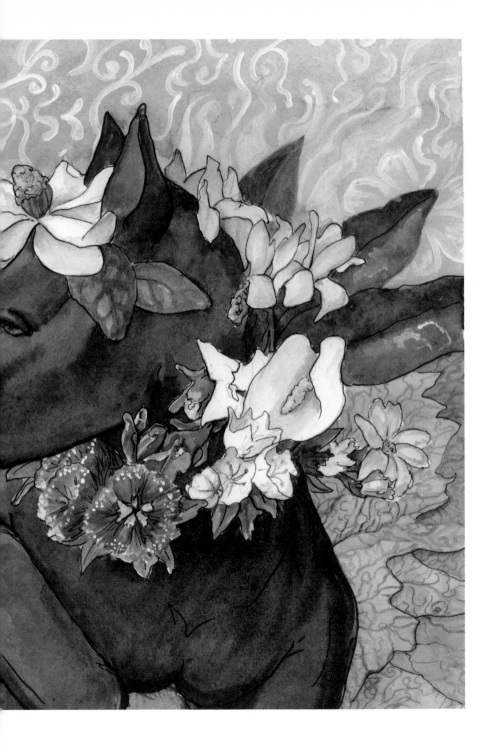

In the morning it was time for Uma's horn to start grow-ing in. Unicorns have a wax seal on their foreheads where the horn will burst through, a horn that hardens with age. Many creatures, including humans, assume unicorns are born with their horns, but evolution has fashioned it so that mothers don't suffer during childbirth and there is no danger of horn damage. This process has always sounded more logical to me than the human process of losing baby teeth to gain a larger set: isn't it easier to grow something that's the right size?

I licked the wax seal off of Uma's head, all the while kiss-ing her and whistling a lullaby about a unicorn who can fly, called Pegasus. Uma stayed still and silent, as if she, too, anxiously awaited her horn's unveiling. The wax was salty, but grainy and rich like molasses. After her head was clean, I sat for the next ten hours watching Uma's horn sprout an entire five inches! It came up in spurts; periodically, some more horn would emerge like stone in the sea making a new island. I sniffed and nibbled the horn to make sure it was strong, noticing with my tongue how nicely spiraled it was. Even at only a third of the length it would become, Uma's appendage had tight curvature drawing up to an extravagantly sharp point that seemed to capture sunlight into a pinpoint the size

of a needle's tip. Uma started rubbing it on a nearby tree trunk to test its potential.

Days with Uma passed so fast that I hardly noticed her coat growing into a luscious dark-chocolate hue. Baby fur was scattered around our nest, providing an additional layer of comfort. Her blue eyes matched the color of the stream we lived beside, sapphire sparkles splintered apart by ripples of light. If I looked at Uma's eye from a certain angle, it reflected a "T" like the precious gem tiger's eye, which shows a cross from every angle viewed. I noticed her keen vision one day, when she saw a crow in the sky flying in from a hundred miles away.

Each day when we ventured out, animals greeted us with licks, barks, yelps, pecks, and hops. A copper-bellied snake tried to slither into our den, which prompted my posting a "No Snakes Allowed" sign. For this, I used my horn to draw in charcoal with a squiggly line, then a straight line crossing out the snake squiggle.

One morning during Uma's second week, she followed me out of Perfectly Symmetrical Canyon into nearby Shamrock Meadow, so she could feed in the open. She watched me graze on fresh shamrocks, and crunched a

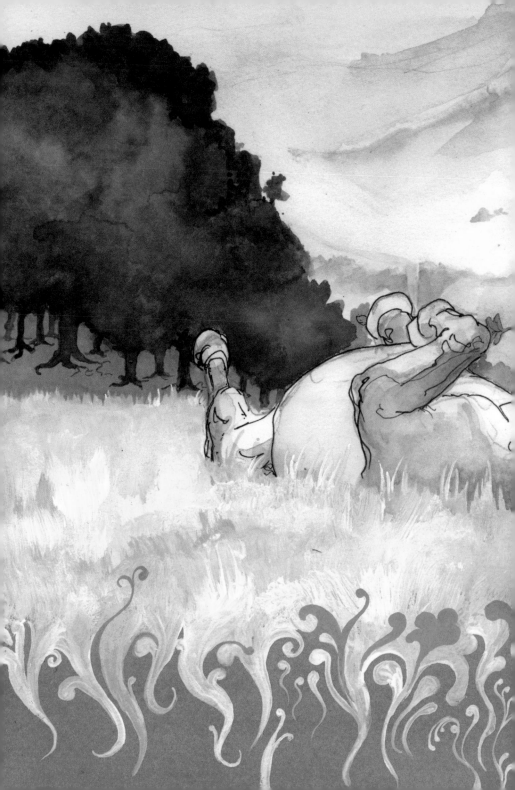

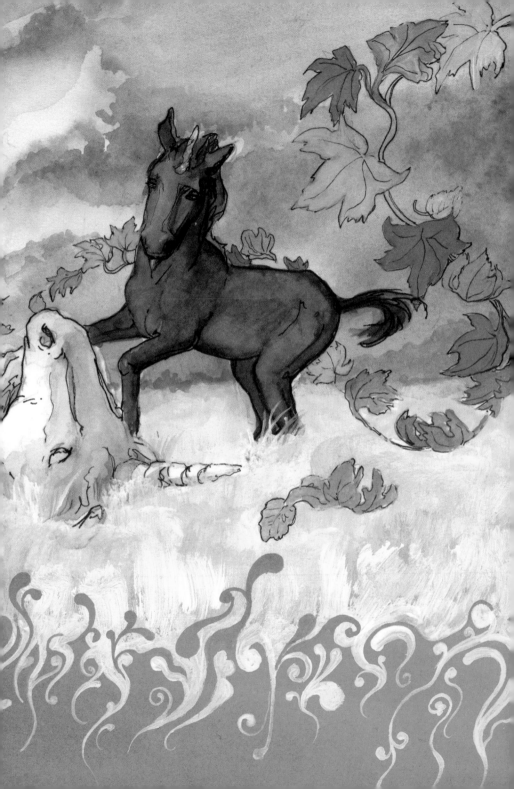

few herself, after which she drank her usual gallon of thick, healthy unicorn milk, making a gurgling sound of satisfaction. I entertained Uma by flipping onto my back. She laugh-whinnied. Then we strolled leisurely together, pausing to entwine our necks into unicorn love embraces.

Unicorn neck posturing is like knot-tying—it's a craft, one that symbolizes affection and trust. This particular afternoon, I taught Uma all the embraces I knew, like the Magnificent Virtue Coil, the Gratitude for Camaraderie Knot, and the Pure and Ardent Love Twist, which makes a heart when two necks are arched together correctly. I knew Uma was going to be an expert in all unicorn love arts, as she was quickly changing from an innocent shamrock snacker into a majestic beauty who would one day be invited by a lovely stag to the Romantic Honey Trails, to mother her own distinctive unicorn.

Communications in Maternal Psychic Paradise

eep into our third month together as a spectacular mother-daughter unicorn team, Uma and I had a fun daily routine. We woke up, sauntered down to the sparkling stream, frolicked in the water, and then trekked a quarter mile up to Columbine Waterfall, where a mallard duck family nested beneath a colony of red columbine plants. Uma liked to compare the colors of the blue waterfall to the red flowers and green-headed, yellow-beaked ducks. The scene mesmerized her each afternoon, allowing me time to gather items for dinner. At night, Uma nursed, then ate the foods I'd collected, sampling everything from sunflower seeds to elderberries, which I mashed up into a pulp for her. Nursing became tricky as her horn length increased. She had to turn her

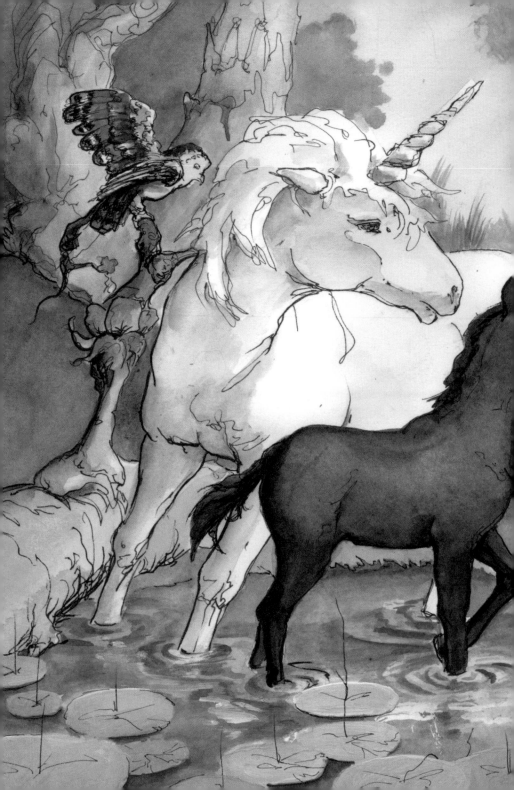

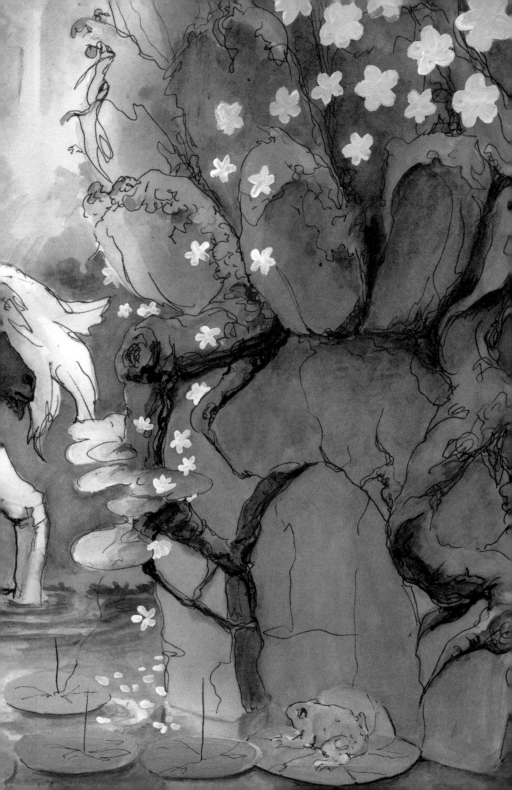

head sideways so as not to stab me with it. I wanted to
wean her and teach her to love a variety of flavors, so
she'd be an adaptable, easy-to-please eater later on.

As the days slipped by in this blissful state, I noticed
Uma practicing vocals with gurgles, laugh-whinnies,
clicks, whimpers, and huffs. Huffing was reserved for
extreme events, like the day she saw a covey of quail
burst out of a ceanothus bush in a flurry of feathers and
cooing. She huffed and reared up, as if preparing to
stomp the action away.

"The stomping of quails is prohibited," I told Uma
after she finished her rampage. "Quails are our friends."

Uma couldn't verbalize yet, so we communicated
through horn vibrations. We touched our tips to transfer
sentiment.

"They are?" Uma asked silently.

"Yes," I replied, nodding my head. "A quail saved my
life."

I told her about the time a quail flew in front of me
when a bobcat was about to attack from above. The
wildcat was sitting in the tree, waiting for me to pass by
underneath. Instead, he pounced on and ate the quail. I
was so impressed by the bird's courage that I awarded
that quail's covey a Heroic Bravery Award in his honor,
working for ten days to clear four tunnels—one in every

cardinal direction—to their dwelling inside a network of tangled, thorny, wild rose bushes.

Uma only comprehended a portion of the story. "Cat," she said, "ate quail."

"Yes," I said, realizing that I had merely reinforced her idea to stomp birds. "But unicorns don't."

Uma winked at me for the first time, and I winked back. We had the same long, delicate eyelashes.

Humans have never witnessed unicorns communicating verbally. Unicorns grow silent around some beings, and under times of stress we become telepathic. When we speak aloud, our language, called Uniform, is heavy with clicks, huffs, and whinnies. Arf once told me I sound like a cross between an overgrown squirrel and an elk.

Uma's vocabulary was increasing exponentially as she learned new words each day. We had lessons in names while traveling through the woods, stopping to sniff, lick, bite, and ogle objects that proved interesting. At home, she had a stash of accumulated items that she liked to line up and point her horn to while naming them—beetle, seed pod, branch. She entertained herself this way every evening before dinner.

One night, I noticed my baby pointing in her line-up to

a live horned toad, which tried to crawl away each time
she pointed to it. It was jabbed repeatedly, being too slow
to escape. Though I was tempted to rescue it, I let her
keep it: this horned toad's sacrifice would save the lives
of others of its kind. When Uma fell asleep, it crawled up
into her bed and rubbed her face with its scratchy, pokey
body spikes for revenge. Uma woke up cry-whinnying
and huffing, but never brought a horned toad home again.

Another night, Uma had a leaf from a castor bean tree,
which exudes poisonous oil from its leaf pores. She was
poking it with her horn. I walked up to her and uncer-
emoniously nudged the leaf off of her horn with mine,
then dropped it outside the hut. Later that night however,
Uma snuck outside and ate the leaf. She had smelled my
scent on it, and figured it was most likely delectable. I
awoke to Uma whinnying and holding her stomach with
her hooves.

"Ouch!" she said.

I brushed her stomach with my mane, which calmed
her.

"Did it taste bad?" I asked.

She huffed a yes.

With my recently acquired tea-making skills, I
selected buckwheat blossoms and sugarbush berries to
make a curative detoxifier, and quadruple-purified the

stream water I brewed it in. Also I boosted the tea with
extra healing power using hoof stomps to align the water
molecules for easier digestibility. This was Uma's first
hot drink, compared to my lukewarm unicorn milk. She
was afraid to try it at first, but eventually lapped up the
whole kettle before falling asleep to recovery.

Uma was of the age where baby unicorns learn to use
the basic five senses, though adult unicorns eventually
develop ten: regular vision, ultraviolet vision, hearing,
the ability to tell temperature, smell, taste, touch, the
ability to feel infrared radiation, magnetism, and sense
of gravity. These last couple run-ins with danger, on the
positive side, proved that she was inquisitive and bright.
Of course, a mother worries that her daughter will get
into real trouble, but unicorns must be allowed to dis-
cover new things. Our need for constant experience is
closely linked to our magical proclivities, and without
magic, we would die. Therefore, even though Uma was
in her nibbling and poking stage, I didn't stop her. Uma
wouldn't learn to practice magic unless she discovered
reasons to perform it.

That Sparkle Following Experience and Discovery

Uma's first winter—the season in which baby unicorns begin using their first five senses to discover the five elements according to the unicorn zodiac—namely water, air, fire, earth, and space—was incredibly rich with experience. Uma was five months old and could now string sentences together. When chill air blasts came nightly into our nest, she began to say, "Let's fix it," or, "Too cold to sleep."

Here was an introduction to the cold, wet element water, and the hot, wet element air. I was so happy Uma was taking action to protect herself against two of the most formidable life forces.

The elements are the most wonderful things we have, partly for their life-saving potential, and partly because of their destructive tendencies. Each unicorn must learn the strategies we've evolved over thousands of generations to not only wield water, air, fire, earth, and space productively, but also to defend oneself from elemental challenges.

Uma and I insulated our nest using sheets of tree bark stitched together with willow string. Uma learned the loop stitch to aid my wooden patchwork. She could sew with the needle between her teeth.

We slept in perfect comfort, once sealed in. Animals came by for slumber parties, since Uma was old enough now to have friends over—we had a houseful of critters. I nicknamed our abode "Uma's Dream-Inn." At one point, we hosted a beaver, a polecat, two tortoises, a possum, a deer foal, rat siblings, and three mice clans. Uma's hand-painted sign, "Get Toasty and Rest!" hung outside our front entrance, encouraging even random animals passing by to stop in. Toward the end of winter, it got out of hand.

"We have to take that sign down, Uma," I said one afternoon, as a black bear checked in. "It's too crowded."

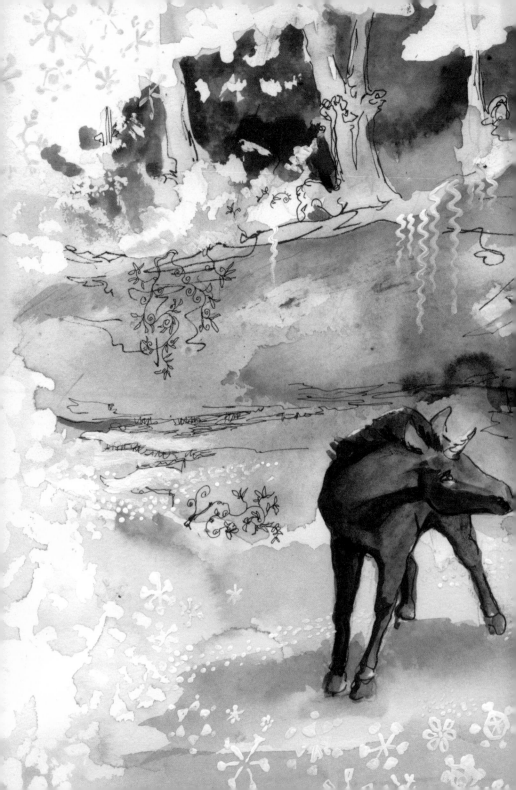

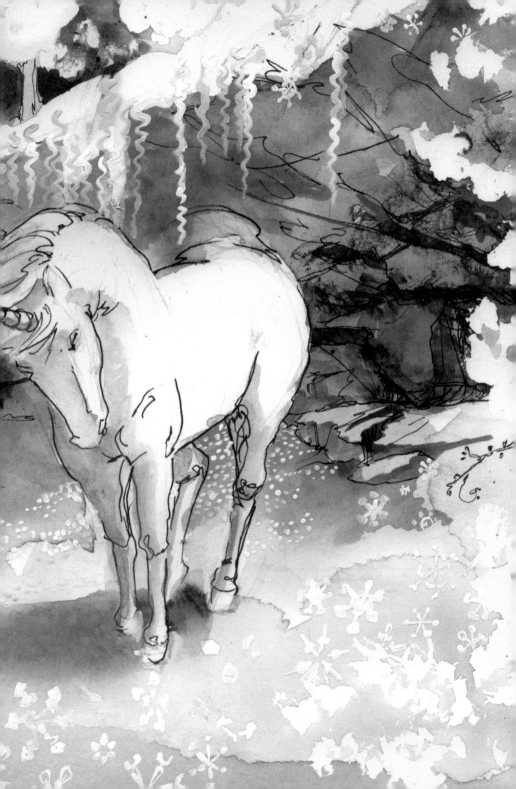

"Our friends are cold," Uma replied. She knew water and air well. And she was right—it is more important to help animal brethren than it is to have a luxuriant sleeping area.

"Okay," I said. "But not next winter."

The bear stayed for two nights before I quietly asked him to please hibernate elsewhere.

Uma was a consummate host, licking everyone who entered. The animals fell especially in love with her brown fur. They argued over who would get to sleep with the beautiful unicorn. Mule deer looked splendidly camouflaged while lying beside her. I loved watching these touching forest events unfold in our home, and briefly recalled the loneliness that spawned my rainbow quests. It was satisfying to observe Uma treating so many creatures with kindness.

Alchemical Transformations of Love-Related Colors

Every unicorn has a birthmark, yet like many others, my mother (rest in peace) never found hers. It's rare for a unicorn to see it. Mine is a small pink spot, called a strawberry, above my left eyebrow. I would have never known it was there, except that I stumbled upon an abandoned mirror in the forest long ago, propped up against a tree. I stopped to sniff it and looked up, thinking that my reflection was another unicorn. Tapping the silvered surface with my horn and finding it hard, I grasped this optical illusion's interpretation of space, our elusive fifth element. Occupying two spaces simultaneously, I was captivated by the idea that animals can multiply spatially. I hadn't thought of space in a while, until the day Uma learned alchemy.

Uma was playing with her friend, Uphelia, who was the grandchild of a unicorn I'd recently met, simply named Uncle. Uncle was a 1,500-year-old stag, crusty from having endured centuries of weather. He had a long beard, and his horn was worn down. I met him at Winter Solstice, when I'd taken Uma to a secret ceremony to witness a lunar eclipse. Uma also met Uphelia there and loved her instantly, so Uncle and I arranged monthly play dates for them to explore the universe together.

Uma was digging with her horn when Uphelia asked if they could practice magic.

They devised a plan to cook up a technicolor-changing potion, also known as hair dye. Uphelia and Uma wanted to match. My daughter told me the whole story when she came into the house with a different coat, dragging between her teeth a star-shaped piece of glass charred to a metallic sheen. She looked so different that I mainly recognized her by her spicy scent.

Uma had stumbled upon this glass while digging with Uphelia.
 "Let's make tea with it," Uma said, also suggesting that they apply it to themselves to change color. She

knew well that my cooked herbs turned to mush,
and thought that boiling the glass would transform it
into a soft paste that the colts could spread on them-
selves cosmetically.

Uphelia and Uma dug a pit to bury the glass star shard,
spreading mud and tar inside to make it kilnlike. They
caked layer upon layer of sealant in the hole and
designed a leak-proof, palm frond–thatched top to cover
the soon-to-be brewing glass. They carried buckets of
water over from the stream and poured them into their
"glass soup." Then they built a fire, heated stones in it,
and dropped the hot rocks into the water until it started
boiling: hot, dry fire and cold, dry earth—a most potent
combination. Two more elements had introduced them-
selves to the young unicorns.

The glass simmered for about an hour. Soon Uma and
Uphelia got tired of watching it and abandoned their
homemade earthen pot, to let it fizzle out. But because
of spontaneous geothermal eruptions bubbling up from
the earth's mantle, the soup kept cooking instead. Gentle
bubbles initially indicating the glass soup's boiling point
evolved into huge, plopping blobs over the course of the
night. The soup turned into a sludgy stew, with the spe-
cial glass as a catalyst.

After their sleepover, Uma and Uphelia checked the spot they'd enchanted the previous night. The hole had widened into a crevasse. The glass star, doubled in size, stuck out from it, blackened with soot and still smoking.

"Rub on it," Uphelia recommended. "See what happens."

"You, too," Uma said.

Uphelia and Uma brushed up against the star, mashing the charcoal matter into their coats. It was gritty and coarsely ground with a glittery diamond powder that had been magically forged during the high-heat, all-night glass bake. At this point, Uma said, things got hazy.

The blackened glass slivers and the sparkling diamond powder coated their fur, starting a chemical reaction: the two unicorn friends became invisible. During this period, which only lasted for about fifteen minutes, they disintegrated temporarily into stardust. When reconstituted, they came out opposite colors—Uphelia brown and Uma white. But how had their first interaction with the fifth element, space, resulted in their color reversal?

Unicorns are the best at transforming. Some of the legends about a goat, rhinoceros, or horse turning into a unicorn are true. Some unicorns also turn into rocks

or trees upon their deaths. Uphelia and Uma visually turned into each other because they loved each other so much. They maintained their own identities while unintentionally altering their pigmentation to emulate the other's. Suspended between floating stardust particles, Uphelia and Uma physically shared space.

This is incredibly hard to do, even for advanced unicorns. Scientifically speaking, the chain reaction was complex. Some of the glass turned to diamond as a result of heat and pressure. The diamond dissolved like chalk in the hot water. The water boiled down, and as the pot scalded, diamond residue dried inside it, forming a powder. The powder coating the glass star was so finely ground that the particles, after being activated, permeated the two young unicorns' fur. This is what helped their bodies, as solid matter, magically split into microscopic atoms, which enabled their invisibility.

Metaphorically speaking, Uma's sense of compassion had allowed her body matter to become weightless enough to intermingle with Uphelia's. She partially became Uphelia the moment her empathy for their friendship was so infinite that she had one hundred percent generosity to offer, forever. When unicorns cosmically bond while sharing space, it means they become best friends.

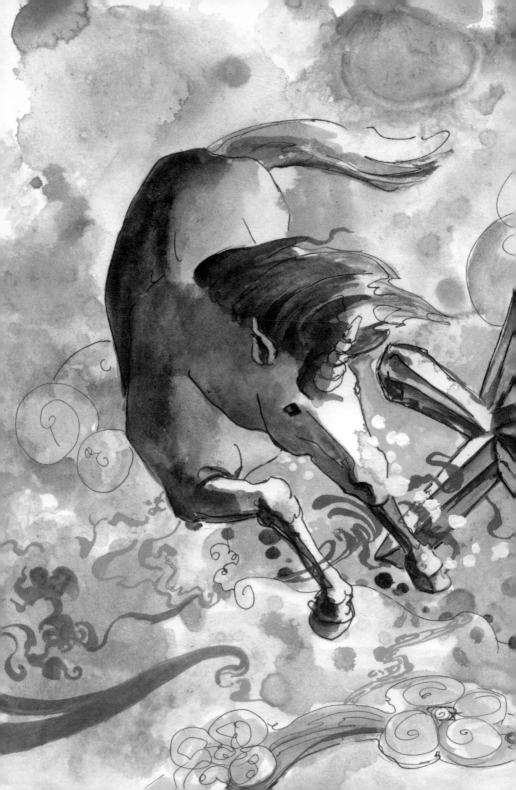

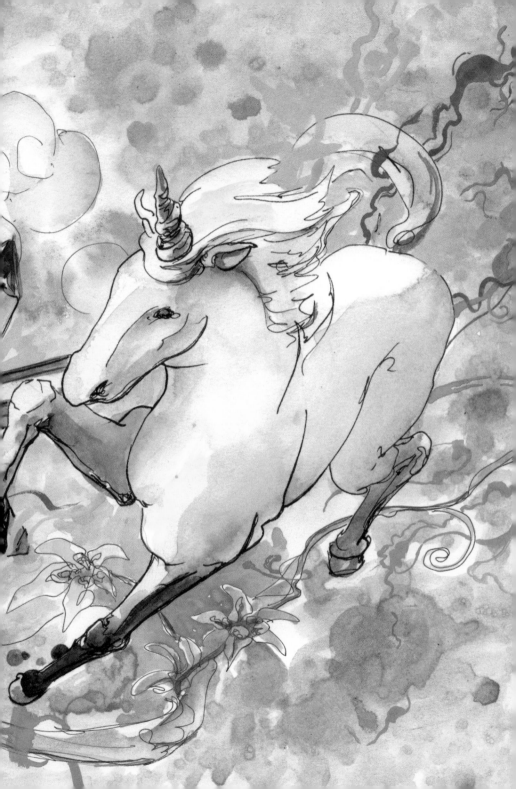

I understood how it worked because motherhood is all about sharing space, giving and receiving. Being born was Uma's first major achievement, and this marked her entrance into magic. I pictured Uma invisible, as she was during her fifteen minutes in the diamond glitter, and realized that invisible, she was transparent like a clear quartz point.

"You grew a crystal!" I noticed, biting a one-inch crystal tip in her forelock to pull it around and show her.

Uma reared up on her hindquarters with excitement.

Sometimes when unicorns do something extraordinary, crystals mysteriously appear. We have theories that bees covertly cement them in our manes with beeswax, as trophies. Remember my mane, decorated with amethysts for the Honey Horn Fair? Uma's first crystal was stunningly tall and slender. Its hairline fractures, in fortune-telling terms, predicted long-lasting happiness.

The End

I would like to thank my editor, Eva Prinz, for imagining this project. Thanks to my husband, Matt Greene, the ultimate creative force in my life. Thanks to Jay Babcock for inspiring peace in my community. And thanks to previous unicorn book authors, especially Robert Vavra, Odell Shepard, and the Stephen Cosgrove–Robin James team, for bringing mythological beasts to life on the page.

—*Trinie Dalton*

The idea for this book was dreamed up after Trinie Dalton and Eva Prinz witnessed the spectacular birth of one very special stallion of the Camargue. Kathrin Ayer brought Trinie Dalton's unicorns to life with her exquisite illustrations, and Deanne Cheuk created even more pictures and stickers for this project. E.Y. Lee thoughtfully designed this book, and Anet Sirna-Bruder and Jacqueline Poirier carefully printed it. This project would not have been possible without the support of Michael Jacobs and Andrea Colvin, who also believe in unicorns.

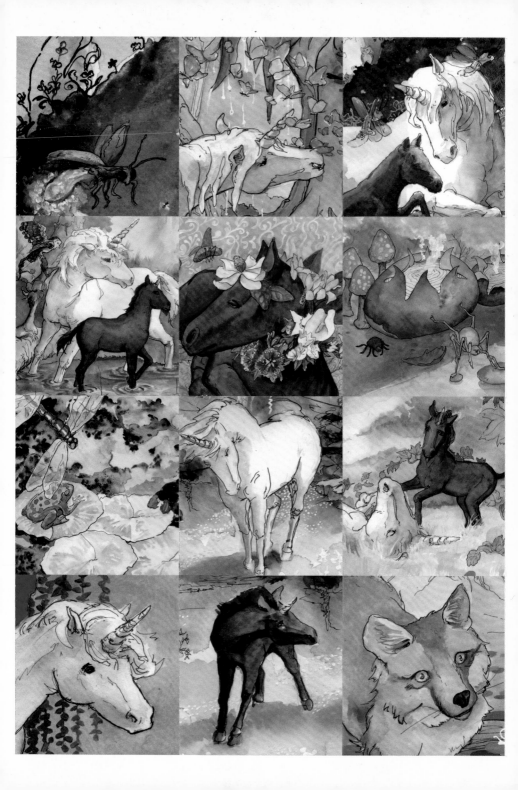

EDITOR: EVA PRINZ
DESIGNER: E.Y. LEE
PRODUCTION MANAGER: ANET SIRNA-BRUDER

CATALOGING-IN-PUBLICATION DATA HAS BEEN APPLIED FOR AND IS AVAILABLE
FROM THE LIBRARY OF CONGRESS.

ISBN 13: 978-0-8109-9439-3
ISBN 10: 0-8109-9439-9

PRINTED AND BOUND IN CHINA
10 9 8 7 6 5 4 3 2 1

HNA
harry n. abrams, inc.
a subsidiary of La Martinière Groupe

115 WEST 18TH STREET
NEW YORK, NY 10011
WWW.HNABOOKS.COM